Skira_Fiction_

David Alan Brown

The Secret
of the Gondola

SKIRA

First published in Italy in 2014
by Skira Editore S.p.A.
Palazzo Casati Stampa
via Torino 61
20123 Milano
Italy
www.skira.net

Printed and bound in Italy.
First edition

ISBN: 978-88-572-1593-8

Distributed in USA, Canada,
Central & South America by Rizzoli
International Publications, Inc.,
300 Park Avenue South, New York,
NY 10010, USA.
Distributed elsewhere in the world by
Thames and Hudson Ltd., 181A High
Holborn, London WC1V 7QX,
United Kingdom.

The Secret of the Gondola

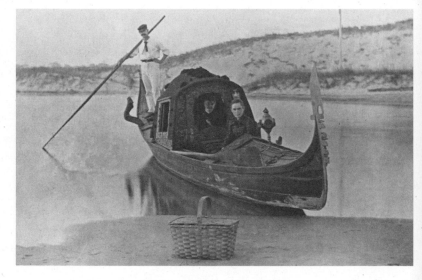

The Moran family in the gondola,
Long Island, New York, ca. 1900

Jeremy Allyn was late again. He was forever late, his former girlfriend had complained. And now he was going to be late for his appointment to inspect Canaletto's masterpiece in the Columbia Museum of Art. It was not that Jeremy was lazy or easily distracted. To the contrary, he always dedicated himself to the task at hand; he just tended to get lost in it.

In fact, there were two sides to Jeremy's nature that were sometimes in conflict. Thoughtful, on the one hand, and intense, on the other, he cherished quiet moments but could also be impulsive. Even before he could read he made up stories about the pictures he found in books and magazines. His parents showed little interest in art. Instead, it was Jeremy's grandmother who took him on an annual outing to the art museum. This event was the high point of his year, and he looked forward to it every day. In the museum, however, it was not the paintings or sculpture that interested him. Jeremy

was entranced by the arms and armor. Installed in the Great Hall, with medieval tapestries as a backdrop, five splendid armor-clad horsemen always captured his attention. At the head of the procession, one of the knights pointed his lance as in a joust or tournament—or so it seemed to a young and impressionable visitor.

Although they were a ritualized form of combat, tournaments could still be dangerous. The blunt force of steel on steel made them potentially lethal. But for Jeremy, long after childhood, they symbolized the romance of chivalry. Courageous, loyal, and devoted to his lady, the knight in armor embodied heroism and adventure until gallantry was outmoded by gunpowder. High school seemed prosaic by comparison, and it was partly to escape humdrum reality that Jeremy attended a nearby college. There, discovering the joy of intellectual exploration, he buried himself in his coursework. The knight errant turned out to have a knack for visual analysis sufficient to qualify for further study.

Professor Osgood at Cumberland University, where Jeremy had become an art history graduate student, assigned him Canaletto's *vedute* as a dissertation topic. The artist's view paintings, especially those depicting the canals, churches, and ceremonies of his native

Venice, were among the most dazzling achievements of eighteenth-century art. But Jeremy soon found that, after his faculty advisor had stopped reading and writing about Canaletto, other scholars had taken up the topic, which was now amply covered in the literature. And if Canaletto was not exactly a household name like Caravaggio (with whom he was sometimes confused), the public had also been exposed to his works through numerous exhibitions. Jeremy would have to find a neglected aspect of Canaletto to concentrate on. He needed a life raft—a gondola, he joked—to transport him to an academic career.

Gazing at a picture by the artist one day, it suddenly came to him: Canaletto was renowned for painting architecture; why not study his figures?

Fortunately for Jeremy the National Gallery of Art in Washington had just held a major exhibition entitled "Canaletto and his Rivals," in which twenty of the master's finest works were displayed alongside paintings by Francesco Guardi and others. Besides offering a survey of Venetian view painting and a virtual tour of the city, the exhibition focused on the rivalries that pitted Canaletto against his fellow painters. It was truly instructive, Jeremy found, to see how each artist had portrayed the same or similar sites in his own way. For Je-

remy, Canaletto was the greatest practitioner of the genre, though he noticed that many visitors seemed to prefer Guardi's flickering "impressionistic" brushwork.

In addition to paintings, the exhibition featured an actual gondola, borrowed from the Mariners' Museum in Newport News, Virginia, as well as two historic camera obscuras lent by the Correr Museum in Venice. One of these optical devices, inscribed "A. Canal," may have been owned by Canaletto (his name being Antonio Canal), who would have used it to heighten the topographical accuracy of his views.

In the exhibition Jeremy had particularly admired the National Gallery's own *Square of St. Mark's*, proudly signed by Canaletto in the lower left corner. Donated by the heiress Barbara Hutton in 1945, this splendid picture and its pendant depicting the entrance to the Grand Canal had once belonged to the Earls of Carlisle at Castle Howard. The two canvases had escaped a disastrous fire at the castle, only to be sold and sent soon afterwards to America.

Piazza San Marco was little changed since Canaletto painted it. Nevertheless, the viewpoint he adopted for the picture, looking southeast past the basilica toward the rose-colored Doge's Palace with it delicate Gothic tracery, was unusual. Between the palace and the

Loggetta at the base of the Campanile, on the right, lay the Piazzetta and beyond that smaller square was a glimpse of sailing ships in the Bacino. The focus on the city's most recognizable monuments, accurately rendered in crisp paint and the clear light of day, marked this as a work of the artist's maturity.

Canaletto had begun his career painting stage scenery, but the drama of his early works gave way, in the late 1720's, to the serene and spacious style by which he was chiefly known. The prime instigator of this change was the entrepreneur Joseph Smith. Resident and later British Consul in Venice, it was Smith who came up with the template that would turn Canaletto's views into souvenirs for foreign tourists. This coincidence of talent and opportunity owed everything to the fact that Venice was a major stop on the Grand Tour, that quintessential rite of passage that added worldly experience to a young gentleman's academic achievement. Among the leading cities and historical sites of Europe, Italy was the prized destination. Having sampled the cultural riches of Rome and Florence, the young milord might find himself in the palace on the Grand Canal where the Consul displayed his paintings and drawings. Acting as Canaletto's agent, Smith sold these and other works by the artist to Eng-

lish clients. His role in shaping Canaletto's style to suit the market could be seen to perfection in Jeremy's favorite painting in the show. The formula Smith urged on Canaletto was "not to paint what the tourist saw but what he remembered," and the Washington picture, accordingly, included the Bacino even though it was not visible from this angle.

A contemporary of Canaletto's might have been describing the *Square of St. Mark's* when he praised the "sunshine" in his pictures. Warm late afternoon sunlight pervaded the scene, Jeremy recalled, casting long shadows onto the square and the church portal. But light here was not merely a formal device; it revealed an amazing wealth of detail. To serve as souvenirs triggering memories of the city, the artist's views needed a requisite amount of detail, just as a portrait ought to resemble its sitter. But Canaletto went overboard. St. Mark's glowing mosaics were fine, and so were the famous horses on the façade, but minutiae like the posters attached to the columns in the Washington canvas clearly exceeded the requirements of the genre. To be sure, crumbling stucco lent veracity to his views, but Canaletto's fixation on such details was time-consuming and impractical. Joseph Smith lamented the painter's slow pace in filling commissions, and

clients likewise grew impatient, grumbled, and turned away. Why pay so much for a Canaletto, one asked, when the same view could be had by another artist for a fraction of the price.

Canaletto's approach combined a broad view of the whole with painstakingly accurate detail meant to satisfy his goals as an artist. The precision with which he recorded a scene went beyond ordinary vision, suggesting that he used a camera obscura to construct his views. Latin for "dark room," the camera obscura had, by Canaletto's time, become a portable box in which an image projected through a lens onto a mirror was reflected on a glass screen, where it was traced by the artist. In this way, the complex reality facing the painter was conveniently organized for use in his picture. David Hockney's bold claim that Western artists regularly employed mirrors and other scientific instruments in creating their works was controversial. But there could be little doubt that Canaletto adopted such a device to achieve his astonishingly realistic effects. The Venetian philosopher Francesco Algarotti, in his *Essay on Painting* of 1762, recommended the camera obscura to artists, and another early source, Anton Maria Zanetti's *Della Pittura Veneziana* of 1771, stated that Canaletto took up this forerunner

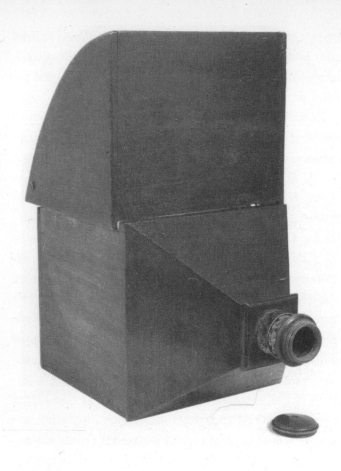

The camera obscura that may have belonged to Canaletto,
Venice, Museo Correr

of the modern camera. The artist's aim in doing so was not photographic accuracy, however, for he frequently altered the scale and arrangement of the buildings in his pictures.

The attention Canaletto paid to detail extended to the figures in his paintings. While his fellow view painters often turned to collaborators for this aspect of their work, Canaletto captured the people, as well as the places, that made up the world he lived and worked in. The *Square of St. Mark's* was a stellar example. Scattered throughout the composition Jeremy had counted almost two-hundred figures ranging from all walks of Venetian society and including foreign visitors distinguished by their dress. In the sun-filled square, monks, magistrates in wigs and gowns, fashionable women, grandees, and beggars, all strolled about and engaged in lively exchange. Under umbrella-covered stalls, merchants displayed bolts of cloth, while a vendor set up his table on the left. Nearby in the Piazzetta a crowd gathered to hear a Dominican friar preach from a temporary pulpit. And, behind the central flagpole, a dog barked at something indicated by its owner. Canaletto had even injected a note of humor, as a large tooth-shaped object hanging from a pole, on the right, advertised the services of a barber/dentist.

Earlier in his career, the artist had dashed off figures, and he would later reduce them to painterly dots and squiggles. But in a work from his prime, like *St. Mark's Square*, they were fully realized. Canaletto's people did not just enliven the scene and lend scale to the buildings. Individually and in groups, they formed a meticulously-detailed portrait of contemporary society. Though they were painted over the architecture and could thus be seen as secondary, Jeremy Allyn would make the case that Canaletto's figures were not an afterthought. The question was whether this splendid portrait of the Serenissima in all its aspects was simply a matter of careful observation. A number of the artist's figures were seen from behind, lending an eyewitness quality to the scene. But was that all?

Professor Osgood objected that Jeremy's approach amounted to little more than description and lacked intellectual rigor. Teacher and pupil agreed that Canaletto's figures were not just taken from daily life, nor were they psychological in the sense of facial expression. They needed to be conceptualized in terms of their comportment. To explain the interaction between the artist's figures, Professor Osgood advised Jeremy to look into Roettgen's 1926 theory of motion transfer. By studying the behavior of his subjects, Roettgen had reached a ground-

breaking insight into their performance. With proper alignment of body and mind and skillful energy management, his subjects were not only physically but emotionally engaged and connected. Though originally devised to account for the give-and-take of sexual encounters, Roettgen's theory had been successfully applied to social intercourse, and it was now a staple of literary studies as well. But Jeremy was skeptical. Even if his advisor's counsel helped to market his dissertation and perhaps land him a coveted teaching job, it seemed of dubious relevance to Canaletto. He preferred another line of research.

Seeking a source for the artist's figural language within the boundaries of his own time, Jeremy had made a happy discovery: eighteenth-century manuals that taught the younger members of polite society how to dance also instructed them in the rules of deportment: how to walk, how to bow and make an entrance, how to converse elegantly. Such instructions tallied well with Canaletto's figures, which appeared to reflect social norms and expectations. Just as the painter rearranged his buildings for aesthetic effect, so his gracefully balletic figures, bending, turning, and gesturing, also made a statement. Beyond the bustle of everyday life lay an elaborate choreography in which every movement had a meaning.

The National Gallery's celebration of "la Serenissima" had one glaring omission, however. Conspicuous by its absence was Canaletto's famous *Bacino di San Marco*. This jewel of the museum in Columbia, South Carolina, was simply too precious to lend. Resisting all blandishments (including a lucrative lecture offer), the curator responsible for the painting claimed that, as the "signature piece" of the museum, it was a magnet for visitors from around the world. Now, to complete his study of the artist, Jeremy had to go there too.

But the painting had not always been so highly esteemed. The "Columbia *Bacino*," as it was called, depicted a favorite site of Canaletto's—the basin, or large body of water, facing the ceremonial center of the city—but did so in an unusual way that had led more than one critic to doubt its authenticity. After the painting was cleaned and critically reassessed, however, and its superb quality revealed, there could be no question about the attribution.

The "rediscovered" picture formed part of the Kress Collection, the largest assemblage of Italian paintings ever brought together outside Italy. Instead of creating a personal monument, dime-store magnate Samuel H. Kress had opted to donate his vast holdings to institutions throughout the United States in the belief that

they would elevate public taste. Kress collections were often sent to cities with Kress stores. Ranging from Cimabue to Canaletto, the best works were reserved for the National Gallery, while the so-called "regional" museums had to content themselves for the most part with lesser examples. Happily, the gallery's first director, David E. Finley, was a South Carolinian, and he made sure the Columbia museum got a fine selection of paintings, chief among them the *Bacino*.

Jeremy deplored the kind of "armchair" art history that relied on reproductions. But it was not just curiosity or the aura of the original that motivated his artistic pilgrimage. Experience had taught him that careful scrutiny of an art object prompted new and revealing insights about it, as if from the artist himself speaking through his creation. Lacking a magic carpet to transport him to his destination, Jeremy drove his secondhand car there on Interstate 95, which runs along the eastern seaboard of the United States all the way from Maine to Florida. The superhighway did not trace an ancient footpath, as might have been expected, but was a modern invention designed to get motor traffic from one place to another as quickly and efficiently as possible. The open road no longer meant adventure, alas, and the stretch leading to Columbia, in particular, was devoid of hu-

man interest. The dense foliage growing along the high-way gave the impression that I-95 had been cut through some primeval forest. In fact, the trees had been planted only fifty years ago as part of a beautification project. The systematic removal of distractions (no shops or services, only corporate logos advertising them) had the advantage, nevertheless, of allowing the mind to wander. By driving to Columbia instead of flying, Jeremy would also save the funds needed to purchase illustrations for his text. But the long car trip was tedious, broken only by signs for places he would probably never visit: Richmond, Williamsburg, and Newport News.

Of course, the Mariners' Museum in Newport News had lent their gondola to the Canaletto exhibition, where it greeted visitors at the entrance to the show. As the principal means of conveyance, gondolas plied the waters in many eighteenth-century Venetian *vedute*. The exhibited vessel, nevertheless, lacked an important feature pictured by Canaletto and his contemporaries—the *felze*, a removable canopy or cabin meant to shield passengers from inclement weather and prying eyes. In response to his inquiry, Jeremy had been told that the *felze* on the museum's gondola was too fragile to travel. Deeply curious about it, he had regretted its absence, and now, glimpsing the sign for

Newport News, he suddenly decided to seize the opportunity and go to see it. Reaching for the smartphone he always carried, he calculated the distance and estimated time to make the detour. With any luck, he decided, a brief stop at the Mariners' Museum would not make him late for his appointment in Columbia, where the *Bacino* still beckoned.

Newport News was one of a cluster of communities making up a vast military-industrial complex at the entrance to the Chesapeake Bay. Crossing the city, Jeremy passed mile after mile of strip malls, which here, as elsewhere, seemed the very essence of the United States (not "E pluribus unum" but "Buy one, get one free"). However nondescript as an urban center, Newport News boasted a great shipyard that was a modern-day counterpart to the Arsenale, from which Venice's maritime fleet set sail.

Now a Biennale site, the Arsenale, at its height, employed sixteen-thousand workmen and an assembly-line system that could turn out one galley per day. Like its illustrious predecessor, the Virginia shipyard had come to symbolize the naval supremacy of a far-flung commercial empire. Railway magnate Collis P. Huntington had established the shipyard at the beginning of the last century, and his philanthropist son Archer, in

turn, founded the Mariners' Museum in 1930. Renovated and expanded, the museum was a low-slung modern structure pleasantly situated in a park.

Jeremy parked his car and entered the museum. Hurrying past figureheads, intricately carved ship models, navigational instruments, and an array of other artifacts from a dugout canoe to the flight deck of an aircraft carrier, he finally came upon the gondola in the Small Craft Center of the museum. Inspecting the *felze*, he saw the gondola in a new light.

The gondolas now used to convey tourists lack a *felze*. Otherwise they have changed little since Canaletto's day. Traditionally black, the long sleek wooden vessel was perfectly suited to negotiate the narrow canals crisscrossing the city. And the flat underside of the boat made it ideal for navigating the shallow channels of the lagoon. Gondoliers stood as they rowed. The forty-foot gondola in the Mariners' Museum had once belonged to the American landscape painter Thomas Moran. With the Grand Canyon falling out of favor, Moran traveled to Venice, where his glowing depictions of the Grand Canal earned him the title of the American Turner. The gondola Moran acquired in 1890 figured in several of his works. Returning to America, the painter brought the craft back with him

to his residence on Long Island, where he instructed a Montauk Indian to serve as gondolier. Moran enjoyed telling friends that the gondola had once been owned by the poet Robert Browning, who died in Venice the year before the painter's arrival. Though the story could not be corroborated, Moran said he liked to think that the vessel had inspired Browning's poem "In a Gondola." Composed in 1842, four years after his first visit to Venice, Browning's verses, Jeremy recalled, told a story of forbidden love ending in tragedy. The unnamed hero and the lady he serenades in a gondola wax poetic about their soon-to-be-doomed romance. An air of foreboding hangs over the lovers' excursion on the lagoon—a watery realm into which they might escape:

"Dip your arm o'er the boat-side, elbow deep,
As I do [...] Death's to fear from flame or steel,
Or poison doubtless, but from water—feel!
Go find the bottom!"

The Victorian melodrama ends abruptly when, as the couple alight from the boat and passionately embrace, the lady's lover is stabbed by three shadowy villains, who may be her relatives:

"Heart to heart
And lips to lips! Yet once more, ere we part
Clasp me and make me thine, as mine thou art."

Whether the gondola carried Robert and Elizabeth Barrett Browning through the canals of Venice or not, the literary connection probably explains why the vessel was preserved, after Moran's death, by a local library that donated it to the Mariners' Museum.

The *felze* of the gondola, Jeremy found, consisted of a black fabric stretched over a frame with a door in front and windows at the sides and back. It was equipped with a seat and chairs accommodating three or four passengers. More than just a canopy, the *felze* was an intimate enclosure calculated to provide both privacy and a view. An old photograph displayed next to the gondola showed Moran's family looking out of the *felze*, with the Indian, pole in hand, in the stern. Overcoming an urge to climb into the cabin, Jeremy continued his inspection. The gondola had recently been restored in Venice, he knew, where experienced craftsmen had returned the dilapidated vessel to its former glory. The black hull had regained its luster, and the polished brass ornament gleamed as never before. With the gondola resting motionless, Jeremy could examine

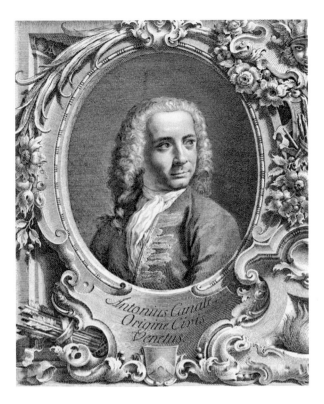

Antonio Visentini
Portrait of Canaletto from Prospectus Magni
Canalis Venetorum (detail), Venice, 1735

I

Antonio Canaletto
Square of St. Mark's
(full view on pages II-III
and details)
Washington, National
Gallery of Art, Gift of
Mrs. Barbara Hutton, 1945

II

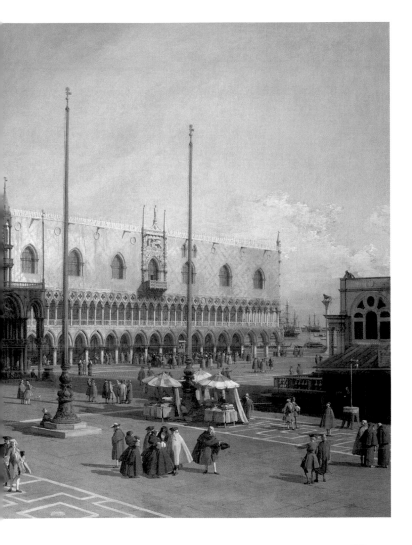

III

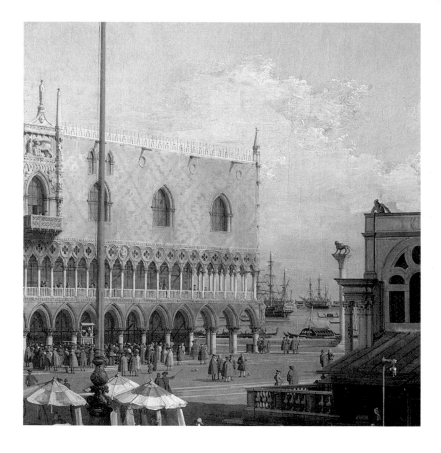

IV

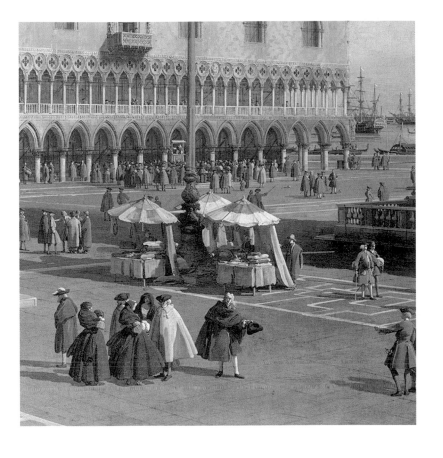

V

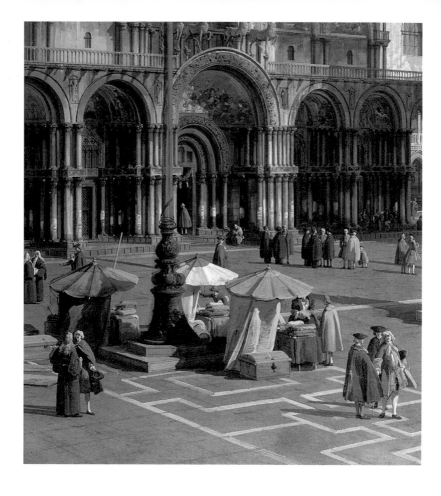

VI

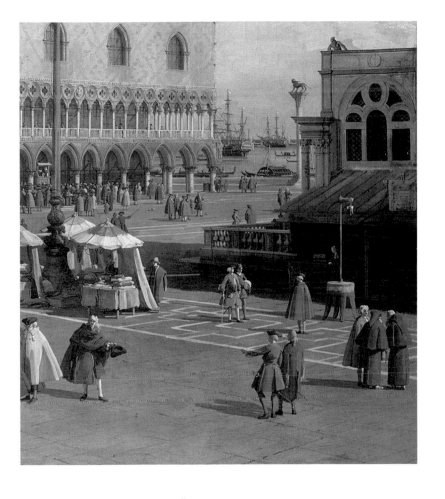

VII

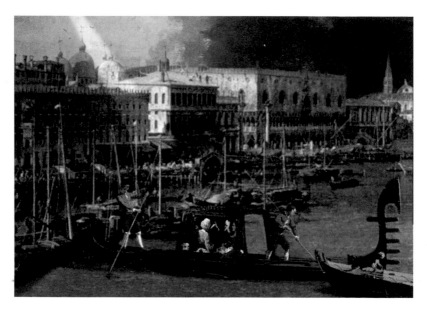

The "Columbia Bacino" (detail)

VIII

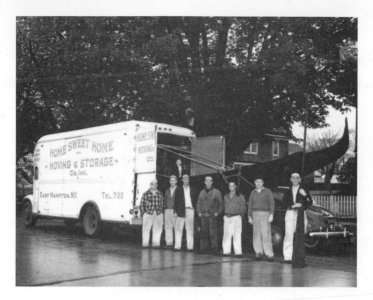

The gondola in transit

its decoration in detail. He admired the black-on-gold sea creatures, particularly the relief of Neptune riding the waves.

But amid all this rich adornment a small but significant detail had apparently gone unnoticed: scrutinizing the decorative swags and swirls, Jeremy suddenly came upon a coat-of-arms. He knew that gondolas were often personalized by their owners, in this case, not

Browning or Moran, of course, but the Venetian nobleman to whom the vessel had originally belonged. The arms comprised a black eagle's wing complete with thigh and talon, against a silver ground.

Jeremy again pulled out his smartphone. Using the camera feature of this on-the-go research tool, he photographed the device, then stored the image for future reference. Next he opened an app, that would serve to identify it. Besides the online resources ordinary folks used to trace their roots, Jeremy's phone had a special genealogical app called "noblesse.com" that was dedicated to the European aristocracy. In addition to identifying coats-of-arms, the heritage site supplied biographical information about their owners.

Jeremy typed in a brief description of the winged claw device, and the answer he sought popped up on the screen: the coat-of-arms he had discovered was that of the Malipiero family. Clicking on the biographical page, he read that the Malipiero, one of Venice's oldest and most distinguished dynasties, had, by the eighteenth century, fallen on hard times. Impoverished but inordinately proud, the most colorful member of the clan was Count Andrea Malipiero, who had married a much younger woman. From what Jeremy could gather, theirs was an arranged marriage and not a hap-

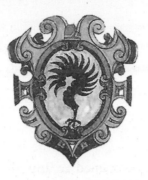

The coat-of-arms of the Malipiero family

py one. Old Count Andrea seems to have had a rival in Giacomo Casanova, who frequented Palazzo Malipiero on the Grand Canal. And Jeremy found that another hint of scandal had also touched the family. A dashing young Englishman, the son of the Earl of Guilford, in Venice on the Grand Tour, had mysteriously disappeared. Nothing was known for sure. But rumor had it that Malipiero's beautiful young wife had granted the missing milord her favors. Browning must have caught a whiff of the scandal, Jeremy concluded, as he quickly exited the museum and resumed his journey.

Driving south, the excitement of discovery soon turned to anxiety as Jeremy worried he might be late for his appointment in Columbia, a few hours away. Traffic added to his woes. After decades of deferred

maintenance, long stretches of I-95 had to be repaired. With the flow frequently slowed to a crawl, Jeremy just followed the car ahead of him. Gazing blankly through the windshield, he thought about calling the museum, but his mind turned to the beginning of the trip and, in the process, he became acutely aware of his solitude.

Like the romantic pairing in Browning's poem, his affair with Amy Cranston had lasted only a few months. A shapely all-American type with blue eyes and sandy brown hair, she had caught his eye on a work-study program, and, as they became friends, he discovered that she was intelligent as well. Over time, their paths crossed, and they soon found themselves attending cultural events and trying out new restaurants. They shared a first kiss and, as the relationship deepened, fell in love.

They also got to know each other better. Jeremy, at twenty six, was still a student, while Amy already had a great job. Despite the economic downturn, she had found work as an engineer in the field of solar power. With a degree in energy and the environment, she had joined a team designing a new system for a leading manufacturer. The system would track the sun's location to help concentrate its rays in generating power during peak demand hours.

Jeremy admired how Amy's technical skills combined with her disciplined character to hold out the promise of a bright career. With his inquiring mind and eye, he was more of a dreamer than a doer. They enjoyed the same things but not for the same reasons. For Amy art and culture were a pastime. She would not have understood why Jeremy's trip was so important. An aesthetic adventure for him, to her it would have seemed like a whim.

The trouble began when they decided to be themselves and communicate clearly. However much she liked or even loved him, Amy found it hard to accept Jeremy's inability to bring matters to a conclusion. He seemed so ineffectual. Their relationship rapidly deteriorated until, without really feuding or breaking it off, Amy just walked out of Jeremy's life. He was distraught. Opposites attract, he reflected, but they don't necessarily connect. Still he often thought about Amy and hoped they might somehow rekindle their romance.

Emerging from a work zone, Jeremy saw the exit sign for Columbia, a hundred miles—and a world—away from Charleston. As if to demonstrate the maxim that the South produced a way of life, not a culture, arch-conservative South Carolina (the Civil War started there) had only one major art museum, located in the

state capital. Having outgrown its quarters in a historic house, the museum had relocated to a new building in the heart of the revitalized downtown, across the street from the Art Deco Kress store (now an ethnic eatery).

When he arrived at the museum, tired but exhilarated, Jeremy grabbed his jacket and stepped out of the car into the late afternoon sun. He usually wore an open collar but decided not to skip the tie for this occasion, selecting one that harmonized with his shirt. He was definitely late, but miracles do happen, and the museum was still open. Inside, he announced his presence and awaited the curator in the atrium, under a newly acquired Chihuly glass chandelier called *Carolina Sunset*. Turning in a circle beneath the fiery red-and-gold orb, he took in the gift shop, an orientation center, and a couple of temporary exhibitions. He also glanced at the list of donors' names inscribed on the wall (the "Canaletto Group" had each given more than five-thousand dollars to support the museum). Would the *Bacino*, which had grown in his mind and which he had come so far to see, prove disappointing?

Looking impatient, the curator with whom Jeremy had an appointment suddenly emerged from the elevator. As Chief Curator and Curator of European Art, Eleanor Sebring had survived several changes of ad-

ministration, as well as the museum's move to the hip part of town. Her tireless dedication and broad knowledge of the collections had made her a "treasure," like the works she cared for. But as she approached, Jeremy sensed that their face-to-face encounter had somehow already begun and was not going well. Ms. Sebring's cool demeanor, in fact, masked a feeling of insecurity. She had never completed her dissertation and resented the fact that Jeremy was about to do so. Tall, lanky, with a mane of dark hair, he looked the very picture of youthful inexperience. Ms. Sebring was obviously in no mood for a chat. "You're here to see the Canaletto?" she asked. Then, brushing aside his apology for being late, she abruptly headed up the stairs, leaving him to follow.

Nicely installed on the upper level, the Italian paintings were arranged in chronological order to form a mini-survey. Without exchanging a word, Eleanor Sebring and her visitor proceeded past the Botticelli and the Bronzino toward the room where the *Bacino* was displayed. Late on a weekday afternoon, the museum was practically empty, the lack of a crowd contributing to the hushed atmosphere. Jeremy overheard an Italian saying she felt the paintings were lonely and wanted to go home.

As they turned a corner, the *Bacino* came into view, and, approaching the object of his quest, Jeremy felt a rush of emotion. Holding up her arms toward the large rectangular canvas in an ornate gold frame, Ms. Sebring invited him to feast his eyes on it. Indeed, the painting more than met his expectations, which were high. Given her long familiarity with the work, the curator was confident she could bring others to appreciate its beauty, as she did. Though she was by no means an expert, this was, after all, her picture, and so, with a guard and a school group looking on, she launched into a lengthy description.

"Venice," Eleanor Sebring began, "rises from the lagoon like a mirage, enchanting all who approach."

With a sweeping gesture, she pointed to the panoramic vista of the basin at the entrance to the Grand Canal. "On the left the Doge's Palace is suffused with light and atmosphere," she observed, while "other palaces and public buildings on the Molo and the Riva degli Schiavoni arch toward the horizon, where sky and water meet."

To the right in the middle distance, Ms. Sebring indicated the island of San Giorgio with Palladio's church and the monastery that presently serves as a library and cultural center. "The bell tower," she con-

tinued, "soaring into the sky and reflected in the shimmering waters of the lagoon, truly captures the magic of this wonderful place." She noted with satisfaction that several preparatory sketches for the complex were preserved in the Collection of Her Majesty the Queen at Windsor Castle.

In the foreground, meanwhile, the basin teemed with barges, gondolas, fishing boats, and other vessels essential to Venice's maritime commerce, and like the architecture, this "symphony of watercraft" displayed Canaletto's "mastery of subtle hues and sparkling detail."

"Fixing an image of the city," Eleanor Sebring's voice rose, "the artist succeeded in rendering it eternal."

But why spoil the picture by analyzing it? The sign of a really great work of art, she always said, was its ability to withstand interpretation. Jeremy's annoying follow-up questions made her feel her account had been inadequate. This would be her last word on the subject. Jeremy had no way of knowing that his guide had a hard-to-get ticket for the exciting new production of Gian Carlo Menotti's classic "The Medium" at the Spoleto Festival in Charleston. With scarcely a goodbye, Eleanor Sebring dashed out of the building, leaving Jeremy to inspect the *Bacino* on his own.

Alone before the painting, Jeremy had no quarrel with what the curator had said about it. But Canaletto's picture was more complicated than might at first appear. Like the *Square of St. Mark's*, which he had admired in the exhibition, there was a question about the viewpoint adopted by the artist. Here there seemed to be two perspectives: one, at ground level, from the Punta della Dogana (Customs House); and the other from an imaginary height, far above the water, which gave a greater sense of depth to the foreground. Also like the Washington picture, the *Bacino* had all the crystalline precision of Canaletto's mature style and technique. Jeremy could almost hear the sound of the oars lapping in the water. Modern studies had confirmed the phenomenal accuracy of detail in Canaletto's views: even the rise in sea level from his own time to ours could be calculated. To obtain such effects, it was argued, Canaletto turned to the technology of his day. Having first sketched the scene, he went on, using a camera obscura, to record single buildings or sites in a series of careful outline drawings made on the spot. The artist then combined these separate views in the finished picture.

Yet despite its similarities to Canaletto's other works, something about the *Bacino* looked odd to Je-

remy. What first caught his eye was the storm brewing in the sky. The artist's views from this period were invariably sunny, but this one was invested with a sense of drama associated with his earliest work for the theatre. The gathering clouds gave an air of foreboding to the picture, as if something were about to happen. Breaking through the clouds, a shaft of light drew Jeremy's attention to one particular boat in the foreground. Canaletto often wrote "sol" on his preliminary drawings to indicate where in the picture the sun was to strike buildings or water. Here the beam of light narrowed the viewer's focus, and Jeremy, taking a closer look, realized that the brightly illuminated gondola was out of sync with the others in the painting.

The boats in Canaletto's pictures were not disposed casually. Nor were they arranged solely for aesthetic effect. Jeremy had come to believe that the watercraft, far from being aimless or merely artful, conformed to an aquatic "traffic pattern." Gondolas, boats for transporting produce and merchandise, and fishing vessels equipped with sails seemed to observe "rules of the road." Before motorboats no formal regulations governed the flow of traffic on the waterways, as far as he knew, only longstanding custom that reflected the hierarchical nature of Venetian society. After the doge's

ceremonial barge, called the *bucintoro*, and other official craft came the private gondolas of the patriciate. In Canaletto's view paintings, this time-honored system resulted in a pattern in which boats with liveried gondoliers had precedence. Enlivened by colorful little figures, the gondolas gliding over the water were usually shown parallel to the picture plane. The spotlighted gondola in the *Bacino*, however, veered off at an oblique angle. Both its eccentric position with respect to the others and the agitated ripples it set off were an anomaly in the painter's practice.

Drawing closer, through the openings in the *felze* Jeremy glimpsed what appeared to be a seduction. The pair of figures ensconced in the cabin, even more than was usually the case with Canaletto, had a real presence and individuality. One, a lovely young woman, was clearly responding to the male companion seated beside her. From what Jeremy could determine, the foremost gondola in the *Bacino* was a love nest. In fact, escapades like the one Canaletto painted frequently occurred in gondolas. The Venetian nobility were not permitted to entertain foreign visitors in their *palazzi*, so they intermingled in locales outside the home—cafés, theatres, and, above all, casinos. There, suitably masked, a countess—or a courtesan—could meet and acquire a

lover. Such liaisons between unfaithful wives and foreigners were the other, less edifying side of the Grand Tour. What better place for a tryst than in the *felze* of a gondola?

There was another sign, too, that the blue-green waters of the Bacino held a surprise. A book could be written about the dogs in Canaletto's paintings; here the ever-present canine, in the bow of a nearby boat, was barking in alarm, but at what? As before, the answer to the question lay in the palm of Jeremy's hand. The digital camera of his cellphone had an imaging feature that made it possible to explore paintings in a new way. The camera could capture high-resolution images of details that were nearly invisible to the naked eye. These details could then be enlarged and enhanced for greater legibility. Bringing the camera up close to the canvas, Jeremy detected something he had not seen before. On the *felze* of the gondola a few dots of paint, under magnification, turned out to be a coat-of-arms. Jeremy knew that Canaletto's own family had a coat-of-arms—a shield with a chevron—which the artist had proudly incorporated in several of his pictures. But this one was different. Peering into the camera, Jeremy was startled to discover that the crest painted by Canaletto was that of the Malipiero—the winged claw he had found on the

gondola in Newport News. An astonishing coincidence, to be sure, but the arms in each case were unmistakably the same. As the *Bacino* was datable stylistically to the early 1740's, before Canaletto's departure for England, the Malipiero gondola in the painting would have belonged to count Andrea, who died soon after the middle of the century. The gondola in the picture appeared to be the very one Jeremy had inspected in the Mariners' Museum. The fact that both vessels displayed the same coat-of-arms inevitably brought to mind the conjectures surrounding the count, his wife, and the young milord gone missing. The two figures Jeremy had made out in the *felze* could easily be the discontented wife and her suitor. The seductive young woman wore a low-cut blue silk dress tightly fitted around the bodice, and Canaletto's careful attention to costume also extended to that of her companion. With his abundant brown locks tied in the back, he was dressed in the relatively informal style favored by the English. The young man's simple frockcoat, worn over a vest, was tailored to show off his physique.

Satisfied that Canaletto was depicting an extramarital fling, Jeremy noticed that the ray of light he had observed streaming through the window of the gondola

penetrated the darkness of the *felze*. There, in the image enhanced by the camera, he was shocked to find a third figure half-hidden in the shadows. With a powdered wig piled high on his head, this sinister character was more elaborately dressed than the others. The magnification feature of Jeremy's camera phone showed off the rich textures of his garment decorated in silver and gold.

Jeremy had scarcely deduced that the ghostly figure lurking in the *felze* was the lady's husband when he made out yet another detail that turned what first seemed an amorous dalliance into a terrifying crime scene. Close up, Malipiero's outstretched arm held a knife, a stiletto to be precise, extra sharp and easy to conceal. Bent sharply at the elbow, the arm wielding the weapon had a blunt force totally unlike the stylized postures found elsewhere in the painting. To Jeremy's way of thinking, it was the difference between a graceful pantomime and genuine passion. As he was propelled into the moment, the *felze* no longer seemed cozy but claustrophobic. Inside, the young man now appeared to be staring imploringly at the lady, who recoiled as her lover succumbed before her eyes.

Trying to understand what had happened, Jeremy pieced together a possible narrative. Because the pre-

meditated crime of vengeance took place in the Bacino, not some remote corner of the lagoon, he concluded that Malipiero had lured the young Englishman into the gondola and, unable to wait until the boat reached a safe distance, dispatched his rival in a fit of jealous rage. To conceal the deed, the betrayed husband would have counted on the privacy of the cabin and on the complicity of the gondoliers, dressed in the Malipiero colors of black and silver. The count's accomplices must have rowed the gondola out into the lagoon and thrown the young man's body overboard. Washed out to sea on the tide that cleansed the city of debris, the body was never found, explaining why the gallant had vanished without a trace. The invitation to join Malipiero and his wife had proved fatal.

Surveying the scene from the Dogana, Canaletto seems to have stumbled upon a murder taking place before him and put it in his painting. To decipher the episode depicted in the *Bacino*, Jeremy exploited several functions of his smartphone. The informational apps provided the context for the murder, while the camera captured its image in the painting. Jeremy wondered whether Canaletto had not also viewed the event through the portable camera of his day—the camera obscura, used as an aid to drawing outdoors. With his

head covered by a dark hood, the painter would have peered into the camera, which framed the incident and brought it into sharper focus. Jeremy could just imagine how Canaletto, breathless with excitement, had quickly sketched the momentary image projected on the screen.

To judge from the painting, Canaletto's preliminary drawing had captured the deed with uncanny accuracy. And yet the painted scene, however dramatic when viewed close up, was not signaled by any change in brushwork or handling. Enmeshed in the pictorial fabric, the incident was also diminutive in scale—a detail integrated into a vast panorama where it long went unnoticed. In effect, the crime portrayed by Canaletto was hidden from the casual viewer, beginning with the patron who had ordered the picture. Such a patron or collector might be noble, but, unable to appreciate Canaletto's precision, he was not the privileged viewer the *Bacino* was ultimately aimed at. The pictorial re-enactment of the crime could be detected only by someone thoroughly familiar with Canaletto's work and as attentive as the artist was to the smallest details. To unlock the deeper meaning in the *Bacino*, this observer would have to look at the motif in the painting as intensely as Canaletto himself had looked at the murder.

Until then the centuries-old crime depicted by the artist would remain a secret.

Canaletto had probably observed the murder with the aid of a technical device, but why did he include it in his picture? One of his foreign patrons claimed that the artist's excellence lay in "painting things that fall immediately under his eye." A stickler for accuracy, Canaletto was faithful to reality as he saw it, and if he accidently witnessed a murder, he had to record that too. Retracing his steps to the museum entrance, Jeremy recalled that in the artistic hierarchy of the time, the genre Canaletto excelled in was at or near the bottom. Attached to visible reality, view painting, like still life, lacked the serious content of history pictures with their grand classical and mythological themes. No doubt the low esteem in which Venetians held his work explained why Canaletto was elected to the Academy only five years before his death, in 1763. The painter charged a lot for his works, nevertheless, and, keenly aware of their value, must have resented this slight. The *Bacino* at least was one view painting that did not lack drama or pathos.

With Jeremy musing over details in the *Bacino*, Canaletto had finally found his ideal viewer. The affinity he felt for the painter went beyond a taste for his

works. The young American and the Italian were unlikely partners in a joint venture. Canaletto had succeeded in preserving the memory of a horrific deed only because, much later, Jeremy Allyn also missed nothing. The discovery he made before the painting more than justified his long trek to study it in the original. As the centerpiece of his dissertation, it would cast the issue of Canaletto's veracity in a new light, and it would enable him to demonstrate the true measure of the painter's genius. But besides bringing him academic success, Jeremy felt his discovery might also redeem him in Amy's eyes. Travel was great for repairing relationships, and Jeremy now wished he had invited Amy along in the hope of smoothing over the rift in their romance. Who knows? With her technical bent, she might even have helped to solve the mystery of the *Bacino*.

As sunset darkened the sky, Jeremy left the museum and began the return trip north. He hoped to reach I-95 before stopping for the night. With the city lights fading behind him, the desolate landscape bordering the highway took on an almost menacing air. The weather likewise had taken a turn for the worse, but, elated as he was, Jeremy took little note of the rain falling on the windshield and the glistening pavement. His exploit—to give the day's events a triumphant cast—

had given him newfound confidence. He had a future as a scholar. And he felt sure that his ability to deploy the latest technology in solving a centuries-old crime would also impress Amy. But it would be days before he might see her. Better to telephone with the good news or, as he was somewhat reluctant to call, text her and attach a scan showing the murder depicted in the painting. He would share the secret of the *Bacino* with Amy, who, even before Professor Osgood or Eleanor Sebring, would be the first to know.

Jeremy pulled out his cellphone and, with one hand on the wheel and the other holding the device, conveyed his glittering prize to Amy. Glancing away from the road, he hardly noticed a large vehicle traveling south in the opposite lane. Its headlights blazing in the darkness, the vehicle—a truck or tractor-trailer—was approaching at full tilt. Sensing that something was wrong, Jeremy quickly tapped out the last words of his message and was about to push the send button when, on a wet curving stretch of road, the oncoming vehicle slid across the median and into his path. Watching helplessly, he honked his horn. The lights were now shockingly close. At the last moment Jeremy slammed on the brakes and, tightening his grip, clenched both hands on the steering wheel, then let go.

Though not a scholarly tome, this little book benefits greatly
from Juergen and Anne Schulz's wonderful library of all things Venetian.
The author also wishes to thank Jeanne Willoz-Egnor and Rachel Conley
for facilitating his visit to the Mariners' Museum, Newport News,
Virginia, as well as Brian Lang for similar courtesies at the Columbia
Museum of Art, Columbia, South Carolina.
At the National Gallery of Art Alan Newman and Lorene Emerson
put the resources of the Department of Imaging and Visual Services
at my disposal, while Imaging Specialist David Applegate made
the digital version of the Columbia Bacino. For the photo of the gondola
in transit, I am indebted to Alfred Conklin and Home Sweet Home
Moving & Storage Company. The East Hampton Library, East
Hampton, New York, kindly offered permission to reproduce the historic
photo of the Moran family in the gondola.

D.A.B